The Art of Mehndi

By Jane Glicksman

Illustrated by Renee Trachtenberg

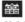

LOWELL HOUSE JUVENILE

LOS ANGELES

NTC/Contemporary Publishing Group

For Hallie and Julia, who lent a hand or two

Published by Lowell House
A division of NTC/Contemporary Publishing Group, Inc.
4255 West Touhy Avenue, Lincolnwood
(Chicago), Illinois 60712 U.S.A.

Managing Director and Publisher: Jack Artenstein
Director of Publishing Services: Rena Copperman
Editorial Director: Brenda Pope-Ostrow
Project Editor: Amy Downing
Designer: Treesha Runnells Vaux
Cover Photo: Ann Bogart
Hand Models (cover): Hallie Schmidt, Julia Clairday

Library of Congress Catalog Card Number: 00-130074

ISBN 0-7373-0458-8

Lowell House books can be purchased at special discounts when ordered
in bulk for premiums and special sales.
Contact Customer Service at the address above,
or call 1-800-323-4900.

Printed and bound in the United States of America
ML 10 9 8 7 6 5 4 3 2 1

CONTENTS

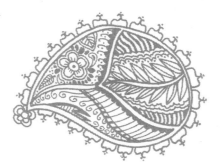

INTRODUCTION

The next time you paint a design on your face for Halloween, color your nails jungle green, or admire your older sister's silver eye shadow, you can thank the Egyptians. The ancient Egyptians, that is. These early trendsetters set the stage for some really cool body art more than 5,000 years ago! We know they used cosmetics, because the Egyptians buried the dead with all the comforts they would need to look really radical in the next world. This included rouge for cheeks, kohl (a bit like charcoal) for lining the eyes, and henna, a magical plant whose leaves (when crushed and mixed with oils and applied to the body) dye the skin and hair a shining shade of coppery red.

In fact, for thousands of years, people from all over the world have been decorating their bodies to express themselves, using clay, ash, and other substances to paint or tattoo stand-out designs. Some people pierce their skin with jewelry, and some even scar their skin to form intricate designs (ouch!). Some of these body decorations, such as tattoos, last forever and others, like clay paint, last only until the next bath.

The latest ancient art made new again is *mehndi*, the Hindu word for henna body painting. Originating in the Middle East and India, the dramatic, dark red designs of mehndi traditionally have been applied to the hands and feet of brides to celebrate their wedding

day. But you can create mehndi designs to celebrate just being you, or any special occasion in your life, like a graduation, a birthday, or making a new friend.

This book will show you everything you need to know to practice mehndi—how to apply it, ideas for designs, even meanings of signs and symbols. Mehndi is safe and, best of all, it's temporary, so changing designs is a snap. Make a statement with mehndi! All you need is your own skin and imagination.

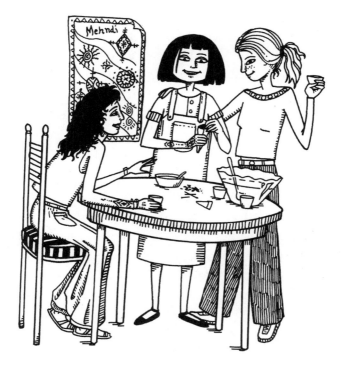

1 HISTORY OF MEHNDI

The fanciful and intricate patterns of mehndi are painted on the body with a paste made from the crushed leaves of the henna plant and a mixture of aromatic oils. Think of your favorite colors in your crayon collection: deep cinnamon red, burnt orange, or sienna brown. The henna temporarily stains the skin with a subtle rainbow of these beautiful reds and browns. The burnished designs of mehndi last from a few days to a few weeks before fading magically from the skin.

Mehndi traditionally has been an art perfected by women, and the patterns and the recipes have been passed down over generations from mother to daughter. The art of henna painting is practiced by people in the Middle East, India, Pakistan, northern Africa, and Indonesia. But no matter where it's practiced, henna painting is often a community effort, one that brings pleasure to both the painter and the painted.

The henna, or *hinne*, in a Jewish Yemenite wedding is a lively affair: The guests present a bowl of henna to the bride and, amid much singing and fanfare, decorate her palms with henna.

Although mehndi is often incorporated into weddings, it's also used for other memorable events, such as the birth of a baby. Mehndi is thought to bring good luck and peace to the wearer.

Henna body decorating is very much like a language, or a secret code. In Morocco, mehndi designs in certain signs and symbols are used to ward off bad luck. In India, mehndi celebrates religious occasions and ceremonies. Henna is thought to possess spiritual properties. Hindus believe that Lakshmi, the goddess of prosperity, lives in henna designs, and great care and thought are given to the pattern, placement, and design of the henna decorations.

While most of us enjoy mehndi for its enchanting and exotic designs, we should also appreciate mehndi for its joyful and ceremonial properties. Mehndi designs can become your personal language for self-expression.

Where Did Henna Come From?

Henna has been used cosmetically and medicinally for thousands of years. Egyptians used henna on their nails, the tips of their fingers, and their feet. In fact, faint bits of henna were found on the hands and feet of mummies buried more than 5,000 years ago. From wall paintings found in Egypt, we know that some men, probably pharaohs, dyed their beards with henna and braided them with gold thread. The Muslim prophet Mohammed used henna to dye his beard, and many people believe that the plant called camphire in the Bible refers to henna.

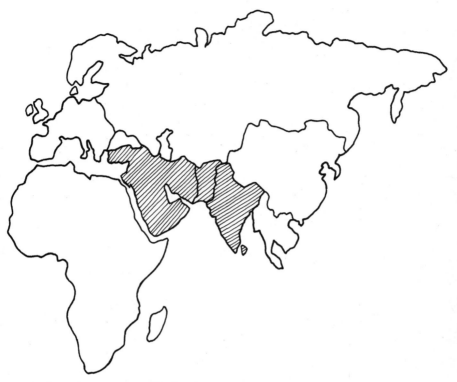

The Magic of Henna

The henna plant was originally grown in the hot, dry climates of Egypt, Australia, Asia, and the Mediterranean coast of North Africa. A cure for many kinds of aches and illnesses, henna has been used to treat sprains, strains, cuts, and burns. A tea made from boiled henna leaves was thought to relieve sore throats, stomachaches, even bad breath! Because henna draws heat away from the body, a paste made from the crushed bright green leaves of the henna plant was applied to the soles of the feet or placed on the palms of the hands to cool and protect the skin or reduce a fever. The paste keeps the skin

from perspiring, so henna might have been used as a deodorant, as well. Imagine how surprised the first henna users must have been to find that when scraped off, the paste left a deep, red color on the skin and kept it cooler than the rest of the body. The reason for this amazing transformation is because the leaves contain a substance that reacts directly with the keratin of hair and skin to form the reddish pigment.

To make the highest-quality henna, the topmost leaves are separated from the rest of the plant. They are said to contain the strongest dye. The leaves are dried for a few days in the sun before being sold to warehouses and markets. The henna you find at specialty stores is already in its powdered form, but at open-air markets in India or the Middle East, some people buy the henna leaves and grind them at home to be sure of their freshness.

2 MEHNDI PREPARATION

Like a cook who carefully guards his or her secret sauce, mehndi artists, especially professionals, are cagey about their henna recipes. Just as there are many different recipes for the chocolate chip cookie, there are many ways to prepare your henna paste.

Many of the ingredients for making and applying your henna paste can be found in a grocery store and your own kitchen. Indian and Middle Eastern markets, herb and spice shops, and health food stores are good sources for henna and some of your other materials. Be sure to check Chapter 4 for more information on purchasing your mehndi supplies.

The Mehndi Shopping List

Show the list below to a parent to see what is available around the house. Then, ask a parent to take you to the store to track down any remaining materials.

Ingredients for Henna Paste

- henna
- coffee
- lemons or limes
- eucalyptus or lavender oil
- orange or rose water
- tea
- bottled water
- sugar
- loofah or washcloth

Extras for Experimenting

- cloves
- tamarind paste or concentrate
- fenugreek seeds
- pomegranate juice or concentrate

Tools

- henna cone (see page 15)
- Jacquard applicator bottle with metal tips in the following sizes:
 .5 for thin lines
 .7 for medium lines
 .9 for thickest lines
 (available at craft or art supply stores)
- flat-sided toothpicks
- bamboo skewers
- scissors
- cloth tape (first-aid tape works well)
- clear tape
- gauze or tissue paper
- tea strainer with handle
- ceramic or glass bowls (You can also use an empty margarine tub or plastic food storage container— *but don't reuse these for anything except your henna mixture. Henna may stain the plastic!*)
- plastic spoons
- cotton balls or squares (make sure these are 100% cotton)
- cotton swabs
- straight pins
- latex gloves

The Main Ingredient

Henna is the star of your mehndi show, so buy the best. Good-quality henna will give you the finest color for your designs. Do not buy bulk henna, as it is rarely fresh and will leave little, if any, color on your skin. Beware of hair-coloring henna, as it may have chemicals or other additives that may not be good for your skin. Indian or Middle Eastern grocery or spice stores are a fascinating place to start your search and get into the mehndi mood. Chock-full of exotic condiments, mysterious cosmetics, and the fabulous aromas of distant lands, these markets provide a window into a new and fascinating culture.

You don't want your henna to be too old or too new. Check the expiration date on the box of henna, and make sure the seal on the package has not been broken. (That dusty, cracked box of henna hidden at the back of the shelf is mostly likely old and will not stain your skin.) Really fresh henna will have a strong herbal odor and will be green in color. Buy only red henna, as this is the only henna that will safely stain the skin. Do not buy black henna—anything sold as black henna contains dangerous chemicals that are toxic to your skin.

Sifting the Henna

Unless you buy presifted henna, you must remove all twigs, stems, and other particles from the henna. If you do not sift the henna, the paste you make will clog your

applicator tools. Although this step takes the most time, it is well worth the effort.

Stretch an old nylon stocking or piece of pantyhose over a glass jar or bowl. Secure it with a rubber band. Next, pour a spoonful of henna on the stocking, then gently brush with the back of a spoon, forcing the henna through the stocking sieve. Discard any particles or other debris left on top of the stocking. The sifted henna should have the consistency of baby powder.

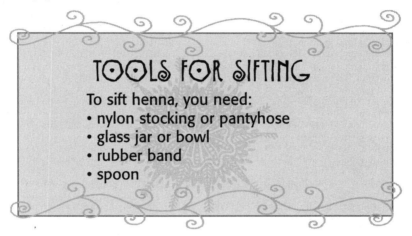

TOOLS FOR SIFTING

To sift henna, you need:
• nylon stocking or pantyhose
• glass jar or bowl
• rubber band
• spoon

Enhancing Your Henna Paste

You'll use dark, black tea or strong coffee to make your henna paste. The darker the tea or coffee, the darker your henna stain will be. Cloves, pomegranate juice, or tamarind (dried or in concentrate) are other ingredients you may use to deepen the color of the henna. You will use a bit of eucalyptus oil and lemon or lime juice as the mordant, or fixative, to bring up the color of your henna paste and

make it last longer on your skin. If you want the deepest color, mehndi artists say, use more lemon or lime juice. Fresh lemon or lime is best, but in a pinch, you can use bottled concentrated lemon juice. If you have the time, the juice from dried limes is the best.

Some mehndi artists use mustard seed oil and oil of cloves to make the paste. It is better to stay away from these oils, as they are quite strong and may irritate the skin. You can find eucalyptus oil or lavender oil at health food stores or aromatherapy shops.

Mehndi Tools

Traditional mehndi artists use a variety of tools to apply the mehndi designs to the skin. Sticks and porcupine quills dipped into the henna paste are sometimes used to draw the intricate designs on the skin. The henna cone, which looks like a pastry bag, is the most popular applicator in the Middle East, but you will probably get the best results using a Jacquard squeeze bottle fitted with a thin metal tip. Still, learn how to make a cone, as you will find it the best tool for filling your applicator 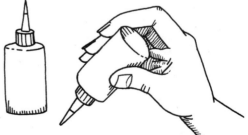 bottles. Eventually, as you grow more expert at application, you might create your own method of drawing.

Making a Henna Cone

To make your henna cone, you need: heavy-duty plastic freezer bag, large size; scissors; and tape.

(1) First, cut the three seams of the freezer bag to create two large sheets. Fold these sheets into fourths and cut into squares—approximately 4" x 5" or 6" x 6". Take one square and trim one corner of it into a rounded shape. This will be the point of your henna cone.

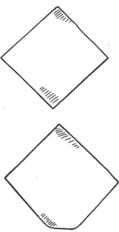

(2) Holding the plastic between your pointer finger and your thumb, roll the sheet into a funnel shape around the trimmed end. Make sure the tip is no bigger than a pinhole. This step will take some practice! It may help to insert two fingers inside the cone to widen it while holding the tip on the outside with your other hand to adjust the size of the hole. You may also try twisting the corner until it appears that the tip of your cone has no hole at all. Your cone should now look like a funnel.

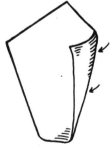

③ Tape the seams all along the side. Reinforce the area around the tip with tape, too, taking care not to cover the hole.

④ To test your cone, squeeze some toothpaste into the bottom of the cone, or drop a spoonful of henna paste inside it. Seal the cone by folding in the sides and folding the top flap down. Tape these seams as well. Holding the cone upright between your fingers, gently squeeze a thin line of paste onto a piece of paper. You should not have to squeeze too hard to get a nice, fine line. If too much paste is released, or if no paste comes out at all, adjust the cone to get the proper-sized tip. When you are satisfied, make several cones.

⑤ If you are filling empty applicator bottles, you may enlarge the hole a bit with scissors. Make sure the tip fits into the neck of the applicator bottle.

SAFETY NOTE

Because mehndi is applied to the skin, you should do a patch test to make sure you are not allergic to any of the ingredients used to make your henna paste.

Test individual ingredients, especially the essential oils, on small areas of your inner arm or behind your ear. Make a very small batch of henna by mixing a bit of henna with enough water to create a fairly thick paste. Let the henna sit for about an hour, then dab a tiny amount on the bottom of your foot. When the henna is dry, scrape it off. Wait 24 hours to make sure you do not have a reaction to the paste. You will also be able to tell if the henna is of good quality by the color it leaves on your skin.

A Few Important Henna Notes

Mehndi takes time! That's the magic of it. Your henna paste needs at least two hours, overnight at best, to "set." After you apply your mehndi designs, you will need to let the designs dry on your skin for 6 to 12 hours to get the deepest, most long-lasting color. If you are short on time, you can still get pretty good results after four hours or so, as long as the quality of your henna is good, and you keep your design moist and warm.

MEHNDI TIMETABLE
HOW MANY MINUTES TO MEHNDI?

Ideal: 2 to 3 days *

1. Get parents' permission.
2. Buy supplies.
3. Sift henna: 15 minutes.
4. Brew tea or coffee for mehndi paste: Steep 4 hours or overnight.
5. Make mehndi paste: leave overnight to cure.
6. Apply mehndi design: 10 to 30 minutes, depending on the complexity of your design.
7. When design is dry to touch, apply lemon and sugar solution.
8. Drink a cup of hot cocoa.
9. Let mehndi design dry to cure: 6 to 12 hours.
10. Scrape off the mehndi paste.

Quick: 5 to 6 hours *

1. Get parents' permission.
2. Buy supplies, including sifted henna.
3. Assemble mehndi paste (includes brewing tea or coffee): let cure for 2 hours.
4. Apply mehndi design: 10 to 30 minutes.
5. When design is dry to touch, apply lemon and sugar solution.
6. Drink a cup of hot cocoa.
7. Let mehndi design dry to cure: 2 hours, minimum.
8. Scrape off the mehndi paste.

* Does not include time to make Dried Limes.

Basic Henna Paste

Here are some basic recipes for henna paste. Once you have been successful, you can experiment by adding a few of the suggested ingredients to deepen the henna color or extend the life of your design. Remember, making henna paste is not an exact science. You may have to adjust the amounts to get the proper consistency.

Recipe 1

This simple recipe can be amended as you become more experienced with mehndi. It makes enough paste to decorate the hands or feet of six people.

- 3 to 4 tbls. black tea leaves or coffee grounds
- 1 cup boiling distilled water
- 2 tbls. sifted red henna powder
- strained juice from lemons or dried limes (see recipe, page 24)

1. Put the tea or coffee in a small bowl. With an adult's help, pour 1 cup boiling distilled water into the bowl. Allow the mixture to sit overnight.

2. Sift the henna powder through a nylon stocking into a glass jar or bowl. (See page 12.) If you plan to keep your henna paste for a few days, you can store it in an empty margarine tub or other plastic container with a lid. Add the strained juice from one lemon or lime (a tablespoon at a time) to the henna powder. Stir the mixture, adding just enough lemon or lime juice to make the henna form a paste as thick as cookie dough.

(3) The next day, with an adult's help, reheat the tea or coffee mixture, but do not boil. Add just enough of the tea or coffee, a bit at a time, to make the henna paste a little softer than toothpaste. Stir until smooth. Do not add too much of the tea or coffee brew at once; you can always add more later as the henna absorbs the liquid. Cover and leave it overnight for the dye to develop. (If you are in a hurry, allow the henna to develop its color for two hours.) Do not refrigerate. Fresh henna paste lasts two or three days before it loses its potency.

DON'T FORGET!

Mehndi is not an exact science. Have some fun experimenting. If your paste is too runny, add a bit more henna powder. If your henna paste is too thick, add a bit more lemon juice or tea mixture. Remember, think toothpaste, and you'll get the proper consistency!

Recipe 2

This recipe is used by Lakaye Mehndi Studio in Los Angeles. It makes enough for 15 to 20 small designs.

- 1 cup water
- 2 tbls. black tea leaves
- 3 tbls. sifted henna
- 1 tsp. eucalyptus oil

1. Add tea to boiling water and steep overnight. Pour the tea through a strainer to keep leaves and sediment from mixing with the henna.

2. Pour sifted henna into plastic bowl. Add eucalyptus oil. Do not mix.

3. Add about 3 tablespoons tea to the henna powder, a tablespoon at a time, and mix together with a metal or plastic spoon. Press the henna mixture against the sides of the bowl to mix thoroughly.

4. Leave undisturbed for at least six hours, preferably overnight. Press out any remaining lumps, and add either more tea or more henna to adjust the consistency of the paste. It should look and feel like toothpaste.

Recipe 3

This recipe makes enough for intricate designs on both hands and feet of one person, or simple designs for about 20 people.

The Brew:

- ½ cup black tea leaves
- 4 cups water
- whole cloves
- juice of dried limes (see instructions, page 24)

The following ingredients are optional but may give your henna a deeper, richer color.

- dried pomegranates
- fenugreek seeds
- instant coffee
- tamarind concentrate

Paste

- ½ cup henna powder
- 2 tsp. eucalyptus oil

(Remember, all measurements are approximate; you must add a little liquid at a time to make a paste with the consistency of toothpaste.)

1 With an adult's help, brew ½ cup strong black tea, a few whole cloves, and the dried lime juice in about 4 cups water. Simmer until half the water is evaporated. You may then add some or all of the optional ingredients (dried pomegran-

ates, fenugreek seeds, instant coffee, tamarind concentrate), simmer for a while longer, then leave the brew to steep overnight.

2. Strain the tea mixture through a fine sieve or strainer, taking care to strain out all leaves, spices, and pieces of fruit.

3. Reheat the mixture, but do not boil.

4. Add ½ cup henna, a little at a time, to the tea mixture. Stir until lumps and pockets of powder have disappeared. The consistency of the paste should be like cake frosting.

5. Add 2 teaspoons eucalyptus oil. Stir again and let stand for at least two hours, preferably overnight. Do not refrigerate.

Tips for Making Henna Paste

1. You may want to use surgical gloves to protect your hands from staining. Be especially careful of your nails. Unless you want them red for the next few months, wear gloves!

2. A general rule in mixing henna is the more acidic the mixture, the darker the stain. If the paste doesn't give a dark enough stain, add lemon or lime juice (which contains acid) to the paste.

Dried Limes

Henna artists from the Middle East swear by the juice of dried limes, saying it turns the henna a deep, dark red. This recipe was found on the Internet.

1. Thinly slice three or four limes. Skewer them on thin bamboo sticks, then set aside for a few days until dried. You will have good results and less mold if you set the skewers in an unheated gas oven. The warmth from the pilot light is just enough to hasten the drying process.

2. When the limes are dry, simmer in distilled water until the water turns red. (This may take 45 minutes or so, and you may have to add more water while the limes simmer.) Let the mixture cool. This juice can be used for any Basic Henna Paste recipe, beginning on page 19, as well as for the lemon/sugar solution on page 32.

3 READY, SET, CREATE!

You've learned how to make henna cones and henna paste, as well as several tips on how to make your mehndi experience magnificent. Read on to discover how to design your body art.

Practice Makes Perfect: Applying Your Designs

Most traditional mehndi designs start with a few basic shapes and patterns: circles, diamonds, and straight and curved lines. If you follow the practice directions for these simple application exercises, you will be well on your way to creating your own masterpieces.

Although you can also use stencils from henna kits or from craft stores, your biggest challenge will be getting the hang of using your henna application tool, whether it is the Jacquard squeeze bottle or henna cone. Hold the cone or the applicator bottle upright between your fingers, not at an angle, as shown in the illustration. The most important

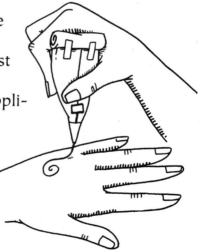

thing to remember is not to touch or drag the applicator tool against the skin. The henna should "drop" onto the skin in a ropelike form. This way, the henna makes better contact with the skin and stains it evenly. Thicker lines yield deeper color.

1 Before you begin the application, sketch your designs on a sheet of lined paper. Use the designs provided in this book for inspiration.

2 Hold your pencil from the top, much as you would your henna application tool. Try not to scratch out or erase your mistakes, because when you are working with henna, you won't be able to start over completely; the henna will begin to stain your skin almost immediately.

3 Practice making parallel straight lines, parallel curved lines, spirals and concentric circles, and hearts and diamonds. Use the lines on your paper as guides.

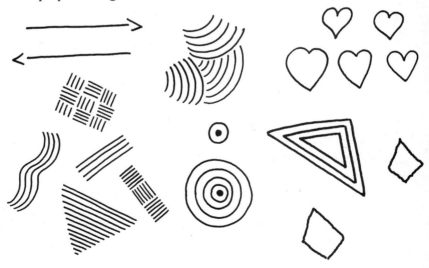

Trial Run

Once you've drawn your designs, try the same exercises using toothpaste. (If your parents don't want you to use up the family's toothpaste, you can make a paste out of baking soda and water.) Fill your applicator with a bit of your practice mixture to get the feel of the mehndi medium. You may use the lined paper again, or draw a mehndi design on a peeled apple or an orange to get a feel for working on curved surfaces.

Practice drawing your designs—do the outline first—then fill them in with your mixture. Use a toothpick or cotton swab to even out lines or clean up extra blobs of the mixture. If you are comfortable, just start doodling!

Practicing Borders

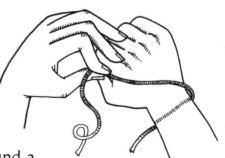

Use the lines on your paper to practice making various borders, bracelets, and straight-line designs. To make an even line around a wrist or an ankle, place a rubber band around the area, then draw! Here is another method for drawing straight lines: Rub some charcoal or colored chalk on paper. (Rub it in thickly!) Then, press a piece of string against the charcoal or chalk until it is well coated. Wrap the coated string around the area where you will be working—the wrist or ankle, for example—and remove it. The string will leave a faint mark. You can then trace over this with your henna.

Below you'll find some mehndi borders you can practice. Then, invent your own!

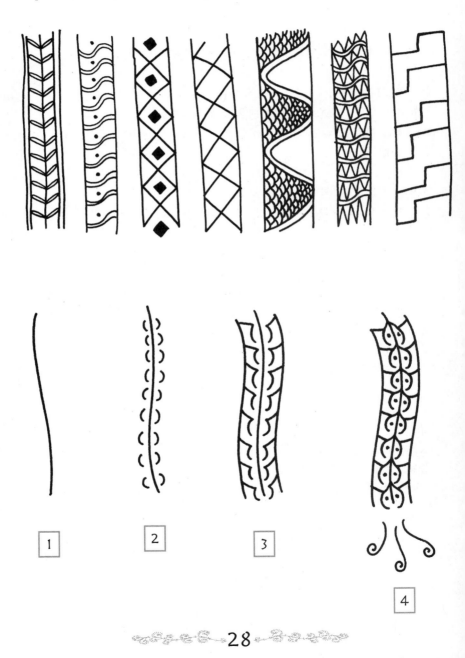

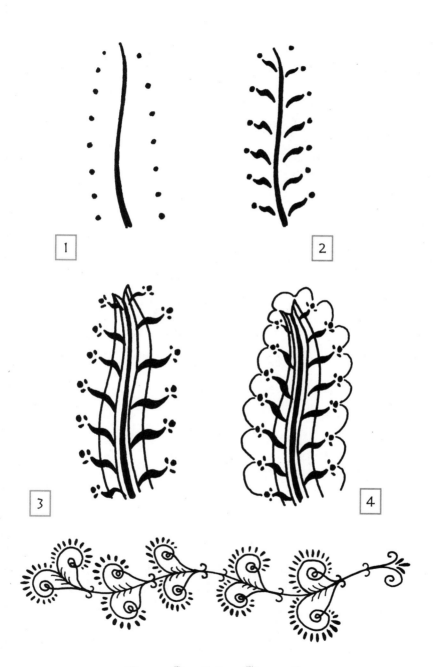

Mehndi Application: Now the Fun Begins!

Before you begin, assemble your tools and ingredients. You will need:

- a bowl of lemon juice or lime juice
- sugar
- mehndi paste
- application tools (the henna cone or Jacquard squeeze bottle). Have enough paper towels on hand to wipe your toothpicks clean or mop up any spills. You may want to use your cotton swabs as well as the flat-sided toothpicks to clean up your designs.

Prepare the Skin

Make sure the skin is clean and free of any lotions or oils. Scrub with a washcloth or loofah, then apply a thin film of eucalyptus oil or lemon juice to the area to be painted. Some people use orange water or rose water to clean the skin—and it smells wonderful! You can find orange water or rose water at stores that sell Indian or Middle Eastern groceries, health food, aromatherapy products, or specialty gourmet food.

Painting

Once you have decided on your design, just have fun!

If you are working on a friend, make sure the person is comfortable, as she or he may have to sit still for quite a while. It's difficult to hold one's arm up in midair, even for five minutes, without having something comfortable to rest it against. Prop up some

pillows, use a footstool, and provide a cushy chair. Painting takes a bit of time and patience—it might take you between 5 and 15 minutes to make a simple design.

Use cotton swabs or flat-sided toothpicks to clean up mistakes, but hurry! Good henna may begin to stain the skin after only 30 seconds. So don't worry too much about bloopers; try to incorporate them into your design. Here's how:
If you make an uneven circle or your straight lines begin to look wavy, enlarge the circle or line with a toothpick to even it out. A blob of henna could be transformed into the center of a flower petal or the tip of a curlicue!

Every so often, turn your applicator upside down and shake it gently, tapping it against a paper towel or newspaper to force the henna closer to the tip of the applicator. In this way, you won't have to use too much pressure to squeeze out the henna, which might cause it to spurt out.

If needed, use a straight pin or tapestry needle to unclog the opening of your applicator.

Drying the Design

After you have finished your design, relax. It takes about 15 minutes for the henna to become dry to the touch. When your mehndi design is dry, you must take this important step to mehndi success—the application of the lemon and sugar solution. This essential part of the mehndi process sets the color and keeps the henna from flaking off. If you keep your design moist, the color will have a better chance of penetrating your skin, giving it a beautiful, deep stain.

To make the solution, mix 1 teaspoon of sugar to one-half of a fresh lemon. (Although a fresh lemon works best to ensure a darker color, you could use bottled lemon juice—about ¼ cup to 1 teaspoon sugar.) If you made a batch of juice from dried limes (see recipe, page 24), mix the leftover juice with sugar instead. Just combine and stir!

Once your design is dry, dip a cotton ball into a bowl of strained lemon juice and sugar, then gently dab it onto your design. Continue to dab with the solution over the next two hours or so (in a two-hour period, wet your design four or five times). Be very careful not to dislodge any henna. If you do, fill in the gap with a bit of watered-down henna paste.

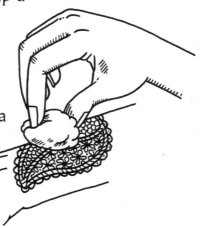

Now is the time to stay warm! One of the peculiar properties of henna is that it needs time and warmth to develop the dye. Your body heat will speed up henna's staining power. Drink some hot tea or cocoa to warm you from the inside out. You may direct the heat from a hair dryer over your design.
Be careful not to dry it out too much, or the henna may crack off. For the absolute best results, leave your henna on for 6 to 12 hours, or overnight.

If you plan to leave your henna on overnight, cover it carefully to keep it from smudging or coming off on your bedsheets. Here's how: Unroll 100% cotton balls and carefully lay the strip over your design. Tape the edges with cloth first-aid tape. It should all hold nicely due to the stickiness of your lemon and sugar coating.

Uncovering Your Mehndi Masterpiece

For the best results, follow these tips:
* **Don't** wash off the henna. Scrape off your design with the edge of a dull butter knife, the edge of a Popsicle stick, or even your fingernail. If you have trouble removing the henna, use a bit of eucalyptus oil, olive oil, or vegetable oil to wipe it off. (Do NOT use mineral oil or baby oil, as either of these may lift off your design.) Gently massage the last stubborn bits and pieces of henna off your skin. Finish by rubbing the area with oil.

● **DO** keep your design dry for at least 4 or 5 hours, preferably 12 hours. If you must bathe, keep the area free from soaps and other lotions, especially suntan lotion. Chlorine will definitely fade your design quickly.

Henna is mysterious—it takes hours, and sometimes a whole day, for its true color to reveal itself. Your design may look very pale at first, perhaps orange. Be patient, and the color will darken over the next few days. Remember, everyone's skin reacts differently. You will find your final mehndi design to be orange-red, red-brown, or even deep brown.

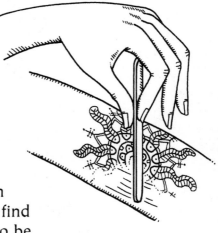

Mehndi Aftercare

To care for your design, keep soaps and lotions away from it. Chlorine, suntan lotion, and harsh soaps will shorten the life of your designs. Try not to scrub the area under your designs. You can rub some eucalyptus oil or lime juice over your design to brighten the color.

How to Be a Mehndi Maestro: Helpful Henna Hints

Keep these tips in mind for a successful mehndi experience:

(1) Practice moving your hand to change the direction of your lines or designs, because you won't be able to move the object you are working on— such as your friend's foot or hand—as you would a piece of paper.

(2) If you are right-handed, start at the lower left-hand corner of your design and move upward, using your pinkie to steady your hand. If you are left-handed, start at the lower right-hand corner and move upward.

(3) Try not to apply designs to areas of the body that bend, such as the back of the neck, the ankle, the part of the wrist next to the palm of the hand, or finger joints. On these areas, the henna will tend to crack or peel off, unless you keep absolutely still for a few hours or more. (Not very easy!) Place anklet designs just above the ankle, and bracelet designs just above the wrist. If you're doing a bracelet, start at the center of the outer or inner wrist area. Extend your design outward to each side until completed.

(4) If you are making a large, solid design, try working on a section at a time. Make part of the outline, fill it in, then continue on to small sections of the design, until it is completed. Don't draw the complete outline first, then fill it in.

Signs and Symbols

Traditional henna designs vary depending on culture and country. Indian and Pakistani designs are intricate and complicated, and are made of certain basic shapes, such as points or dots, stars and circles, or flowers and animals.

Moroccan designs are more geometric in form, and many are thought to have special powers. Middle Eastern designs, especially those made by people of the Muslim faith, are more simple and free flowing, and often are made of floral patterns.

Here are some shapes and symbols, along with their special meanings and powers, that you might like to try on your own.

In India, a **triangle** is often thought to signify creative power.

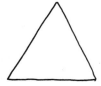

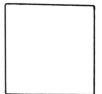

A **square,** one of the most common Hindu symbols, signifies stability, honesty, and dependability.

A **hexagon** is a form often found in nature—think snowflakes and honeycombs.

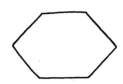

Each of the points on a five-pointed star, or **pentagram,** signifies sky, air, water, earth, and fire.

A **mandala** starts with a circle, and just like a wedding band, symbolizes eternity, or never-ending harmony. A mandala can also contain circles within circles, or squares within circles. Here is a mandala design broken down into simple steps.

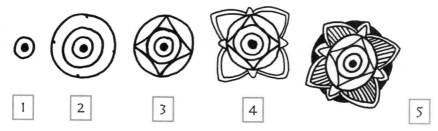

A graceful **fan** symbolizes tranquillity.

Symbols of joy, **flowers** are often used in Indian, Moroccan, and Middle Eastern mehndi designs.

Animals

Birds are a common animal motif in Indian mehndi designs.

The **peacock**, the national bird of India, is a romantic symbol, and is thought to help a wife through extended separations from her husband. It also symbolizes love, luck, and prosperity.

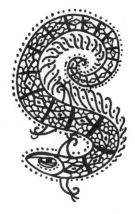

The **swan** is a symbol of success. It also symbolizes long-lasting love because swans are known to mate for life.

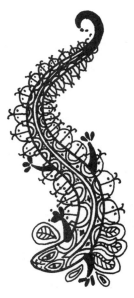

The **lizard** signifies the wearer's search for enlightenment.

Moroccan Signs and Symbols

The hand and the eye are important symbols in Morocco—most often bringing the wearer good luck and guarding against evil. Try using these **El ain**, or eye, symbols for extra protection! If you wear something with the number 5 in it—a hand, or one of these symbols, you will also be protected from harm.

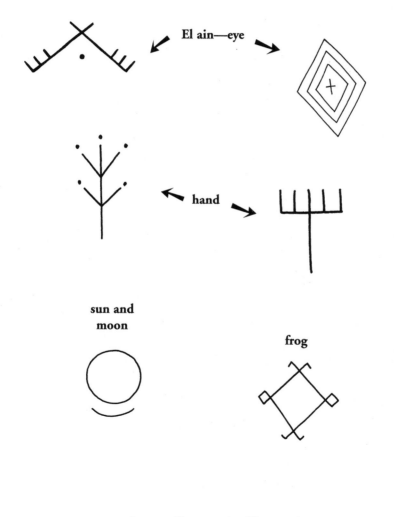

El ain—eye

hand

sun and moon

frog

Chinese Signs and Symbols

The familiar **Yin/Yang** symbol brings together the qualities of opposites— the hot and the cold, the strong and the weak, the male and the female. It also signifies harmony and balance.

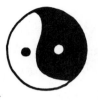

The **peace** symbol signifies serenity and harmony with others.

The more you look around you, the more inspiration you will find for your mehndi designs. Textile patterns and gardens, mosaics or tiles, and paintings are wonderful places to find hidden designs. If you look carefully at feathers, leaves, even numbers or the letters in your name, you will see starting points for designs and patterns.

You can also get ideas from architecture books, font (lettering) libraries, and illustrated manuscripts.

A Henna Party

The tradition of mehndi has always been a social one, most often celebrating happy occasions.

Henna parties celebrate not only a special occasion but also the joy of friendship and families. Why not have a henna party of your own? Because the henna process takes some time, it will give you and your friends the perfect opportunity to get to know one another even better. Add some of your favorite music and food, and you'll have a truly memorable event, one that lasts long after everyone has gone home.

Party Pointers

- First, make sure all your guests have permission from their parents to use the henna.

- Create some atmosphere! Light candles, scatter comfy pillows around the room, or put on authentic Middle Eastern or Moroccan songs.

Your local library may have an international music section.

- Plan to start your party early—around noon if it's a daytime party; about 4 P.M. if it's an evening or sleep-over party.

- If you are serving food, make a batch of henna paste first. Let it set while you eat. Plan to make your henna cones beforehand, too.

- Have everyone contribute ideas for designs or patterns. Draw them on poster board and display them around the room.

- When you're ready to begin applying the mehndi designs, make sure you have enough supplies for everyone—flat-sided toothpicks, cotton swabs, applicators, paper towels, and so forth.

- Have a few activities planned for the time it takes for the mehndi to "set." Watch a video, play a game of truth or dare, trade jokes and riddles, ponder the universe, and, most of all, celebrate friendship!

On the following pages you will find more sample mehndi designs to use. Or, be creative and come up with your own!

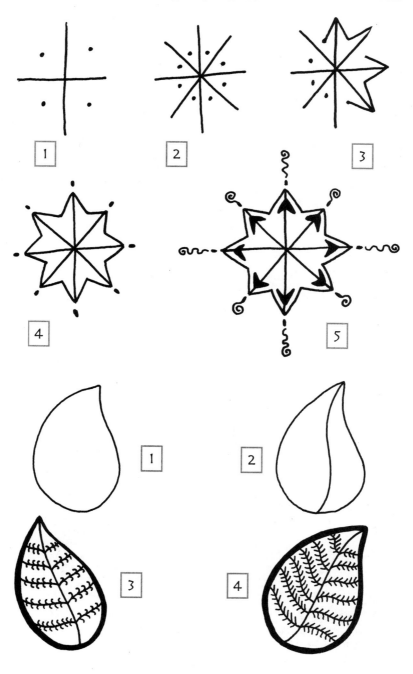

1

2

3

4

5

1

2

3

4

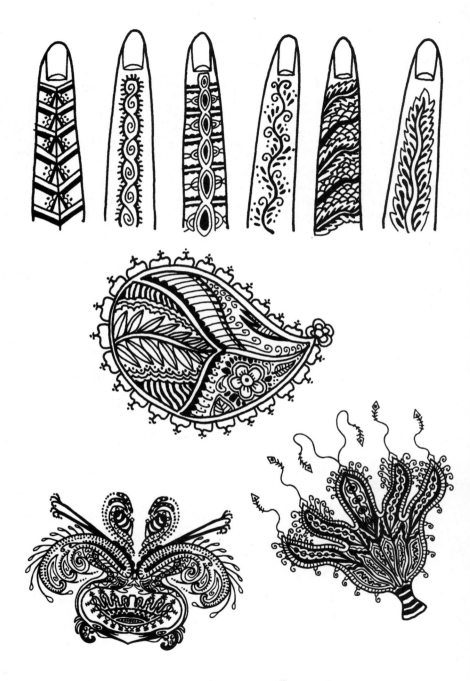

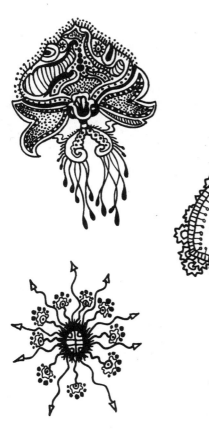

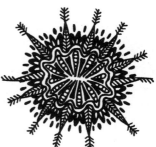

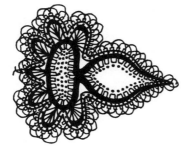

4 HANDY MEHNDI SOURCES

Mehndi has become such a popular art form that many companies dedicate themselves to providing customers with everything they need to create mehndi art. Below you'll find many sources to turn to for information, materials, and ideas.

For Supplies

Artemis Imports
P.O. Box 68
Pacific Grove, CA 93950
831-373-6762
Available: Moroccan henna powder and stencils.

The Body Arts Company
323 E. Matilija
Ojai, CA 93023
1-800-300-9901
bodyarts@fishnet.net
Available: presifted henna, complete mehndi kits, and design books.

Body Art Supply
1-888-99-HENNA
http://www.bodyartsupply.com
Online supplier of mehndi kits containing presifted henna, cones, applicators, stencils, design books, and instructions.

Color Trends
5129 Ballard Ave. NW
Seattle, WA 98107
206-789-1065
Available: presifted henna, mehndi kits, tools, and essential oils.

Kalustyan's
K. Kalustyan's Orient Expert Trading Corporation
123 Lexington Ave.
New York, NY 10016
212-685-3451
Wholesale and retail suppliers of spices, oils, and other Middle Eastern ingredients. Mail order available.

Lakaye Mehndi Studio
1800 N. Highland, Ave., #316
Hollywood, CA 90028
1-800-224-5600
Available: superior mehndi kit that includes presifted henna, tools, metal-tipped applicator, stencils; also sells design books, tools.
www.earthhenna.com

TapDancing Lizard (Mehandi)
4237 Klein Ave.
Stow, Ohio 44224
Available: mehndi kit
TapDancing Lizard, part of the Mehndi Webring; lots of mehndi information, recipes, designs, information. Excellent site.
http://www.tapdancinglizard.com/mehandi

Henna Brands to Buy

If you plan to buy henna from a specialty store, look for the following brands for best results:

1. Reshma Henna (must be sifted)

2. Shelly Mehndi Powder (must be sifted; do not buy the tubes)

3. Sada Baha Dulhan Mehndi-Red (must be sifted)

4. Afshan Mehndi Henna Powder

5. Rainbow Henna in Persian Sherry

6. Mumtaz-Al Aroosa Superior Quality Henna

Mehndi Web Sites

Mehndi Magic
http://www.mehndimagic.com

The Art of Mehndi
http://www.geocities.com/Broadway/5602/mehndi.html

Henna Body Art
http://www.hunza.com

Manju's Mehndi
http://www.henna-art.com

Mehndi Mania
http://www.mehndimania.com

The Henna People
http://www.thehennapeople.com

Mehndi Body Art
http://www.mehndibodyart.com/home.html